START
with a
dot

PETER H. REYNOLDS · ABRAMS NOTERIE · NEW YORK

Design: Hana Anouk Nakamura
Editor: Karrie Witkin
Production Manager: Alison Gervais

ISBN: 978-1-4197-3258-4

Printed and bound in China
10 9 8 7 6 5 4 3 2

ABRAMS The Art of Books
195 Broadway, New York, NY 10007
abramsbooks.com

Dear Bryan
Make a Mark
Shy

This Journal
belongs to...

IF YOU CAN MAKE
A DOT, THEN YOU'RE
READY TO BE TAKEN
ON A CREATIVE JOURNEY.

Every journey begins with
a first step... or a single dot.

This journal will encourage you
to KEEP GOING, to let
your creativity flow
to see things in a new way,
to nudge you to be
a bit braver, and to
inspire you to EXPRESS
more "you" and share it
with the world.

 # Relax.

Don't worry about getting it "right."
The quest for perfection
often can squelch your efforts.

PERFECT-ISH
IS PERFECTLY FINE.

.

I'll be encouraging you
to sign your name.
BE PROUD OF YOUR MARKS.
Own them.
It'll drive you forward!

DREAM. VISION. FLOW.

Making marks will help
you detatch from reality,
loosen up, see new possibilities.
When you're in flow
you'll have one foot
on the ground and
one in the
dream world.

DOT-MAKING TOOLS

How you decide to make your marks is totally up to

YOU —

but I encourage you to try out different tools. EXPERIMENT! PLAY! HAVE FUN!

PENCIL

DOT
STICKERS

WATER-BASED
MARKER

BRUSH-TIP PEN

INK PAD & THUMB

GEL PEN

COLORED
PENCIL

For best results, use
WATER-BASED markers —
Permanent markers, like sharpies
will bleed through the paper.

(UNLESS, OF COURSE YOU LIKE THAT EFFECT!)

Start with
a
D●T.
GO AHEAD.
Just a dot.

Now—sign it!

Now

Make a
BIG
dot.
ANY COLOR

ADMIT IT.
Feels good
to make dots!

Making a dot is

EASY,
FUN,
QUICK
and
SATISFYING.

Just like us,
no two dots are
EXACTLY
the
SAME.

Just <u>TRY</u> to make
two IDENTICAL DOTS!

NOT EASY, RIGHT?

Fill these pages with

dots of many colors...

KEEP G●ING!

Fill this page
with lots of dots!

ANY SIZE, ANY COLOR!

Just let your dots flow

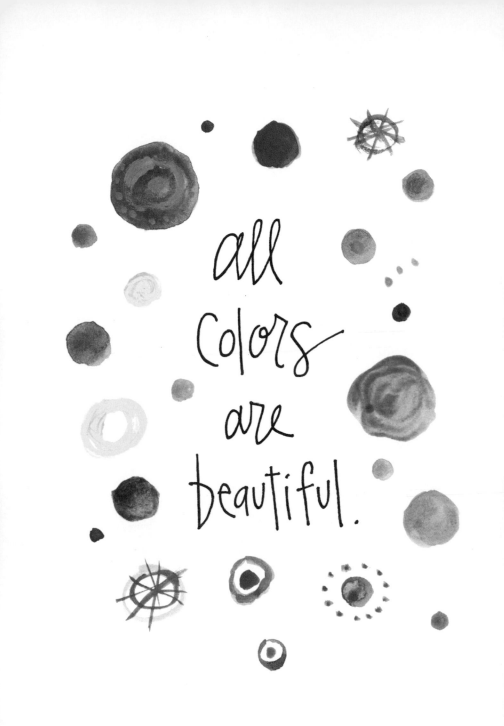

But try to choose your favorite color
and make a BUNCH of dots in that LUCKY color.

dot... dot... dot.

Now...
look at the
dots you've
made....

ORDERLY DOTS?

Scatterly dots?

BIG DOTS?

BOLD DOTS

TEENY-WEENY DOTS?

Same size-ish
dots?

Why not try making a do̅

A FURRY DOT.

A delicate dot.

A cross-hatch dot.

A swirl of dots.

Go ahead...

make more dots.

Need a dot nudge?
TRY A COLORED
PENCIL.

How about an ink pad? Use your thumb or fingers to make a dot-ish *dot!*

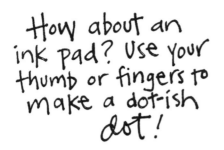

REMEMBER: NO RULES. HAVE FUN. GET MESSY.

More pages for...

more dots!

DOTS

can be designs.

TRY DRAWING A DOT WITH DOTS.

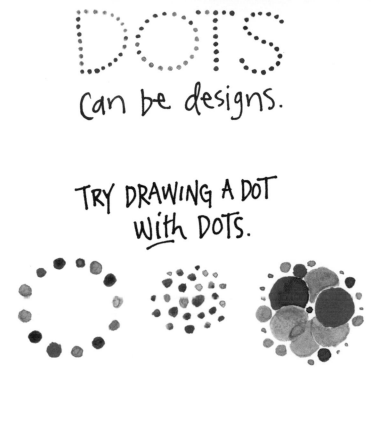

DOTS WITHIN DOTS.

TRY MIXING UP COLORS

Dots surrounded
by dots.

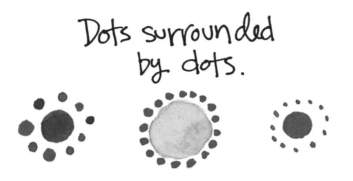

Dotted lines spiraling
around and around.

Fill these pages with your own designs...

Remember: This is your journal. No rules but yours.

Mindful Marks

· · · · · · · ·

C L O S E

your eyes and
make as many
dots as you have
been alive.

You can turn your dots into things
with a few extra lines...

TREE-ISH

LOLLIPOP-ISH

ICE CREAM-ISH

PIZZA-ISH

WHEEL-ISH

SUN-ISH

BUTTON-ISH

FACE-ISH

PLATE-ISH

Now, make some dot-ish things...

WITH YUR CREATIVITY...

Dots with wings

become birds.

Dots with strings

become balloons.

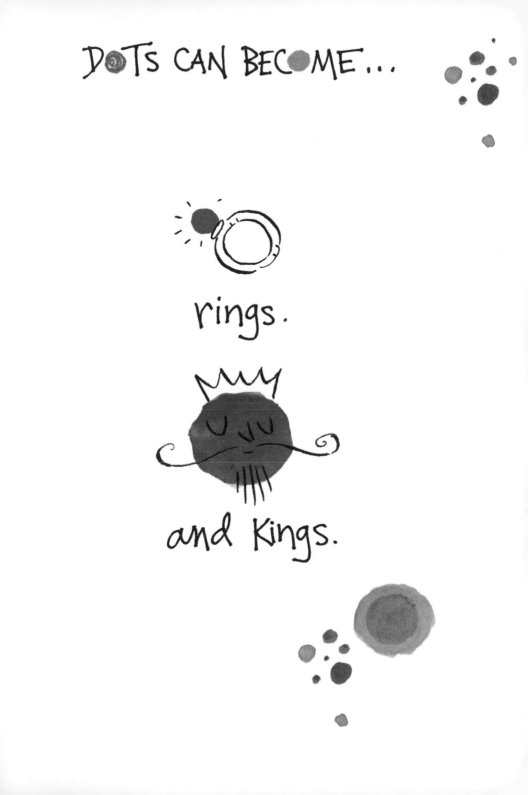

DOTS CAN BECOME...

rings.

and Kings.

Make some dots
and turn them into
 anything that
springs to mind...

More space for doodles on dot

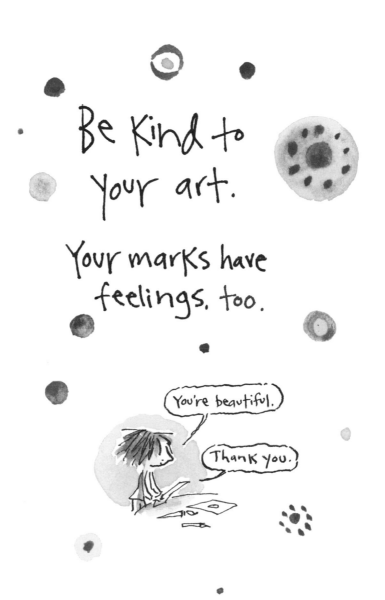

Mindful Marks

How are you feeling today?

MAKE DOTS TO MATCH YOUR ENERGY.

Draw a dot that captures
the spirit of each word.

FUZZY ↘

PULSING
←

SOLID

Use color, texture, and gesture
to get the feelings across.

SQUISHY
←

EXPLOSIVE
←

SAD
→

Make more dots
with different characteristics...

TRY DIFFERENT TOOLS: PENCIL, CHINA MARKER, PAINT BRUSH, COLOR MARKER.

Fill these dots
with your favorite words.

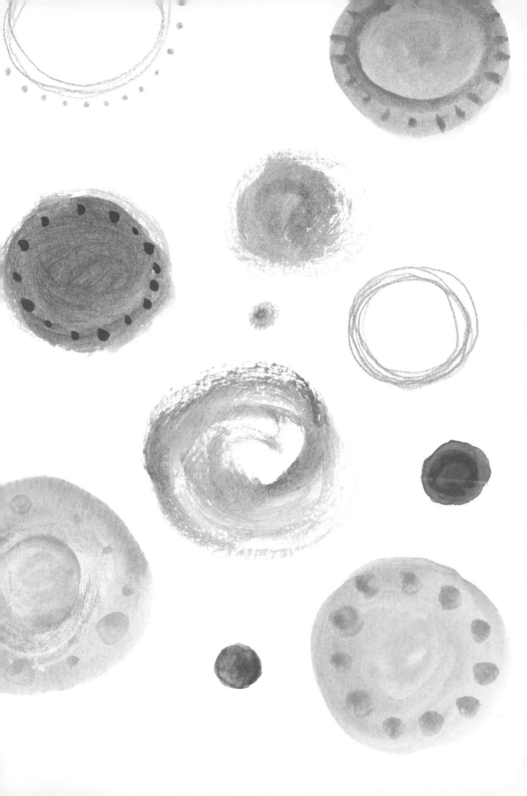

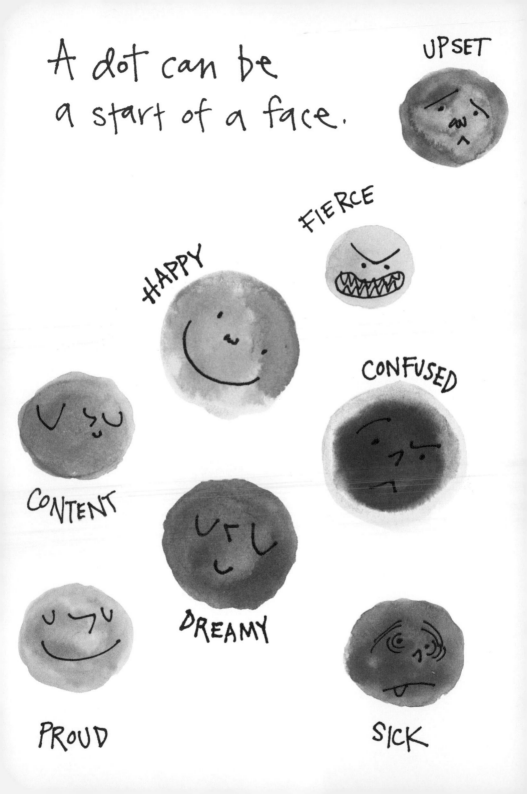

A dot can be
a start of a face.

UPSET

FIERCE

HAPPY

CONFUSED

CONTENT

DREAMY

PROUD

SICK

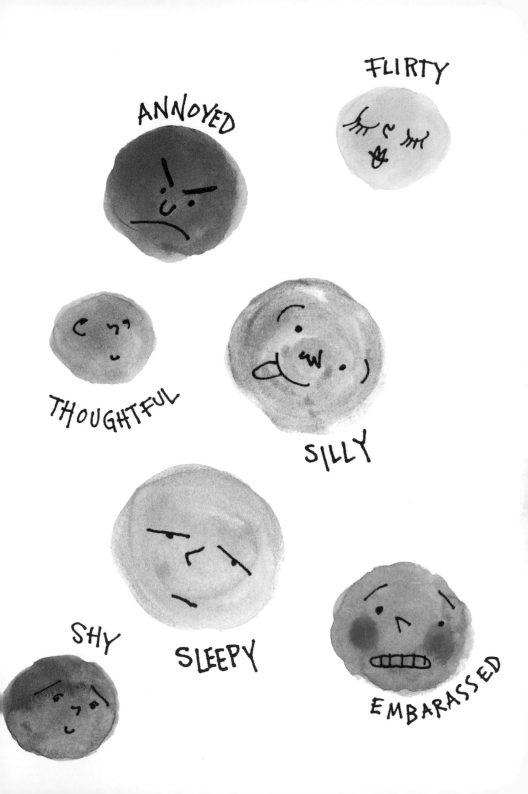

Glasses
maybe?

Add
hair.

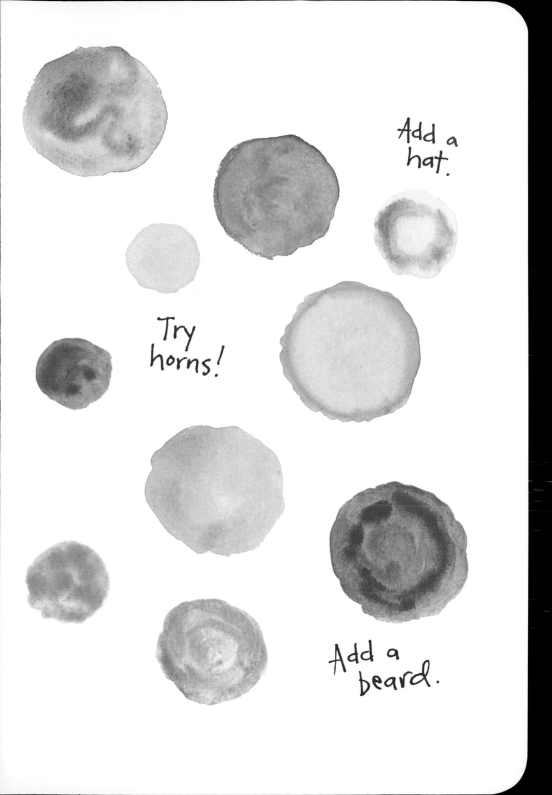

Add a
hat.

Try
horns!

Add a
beard.

Now create your own dots

and make faces.

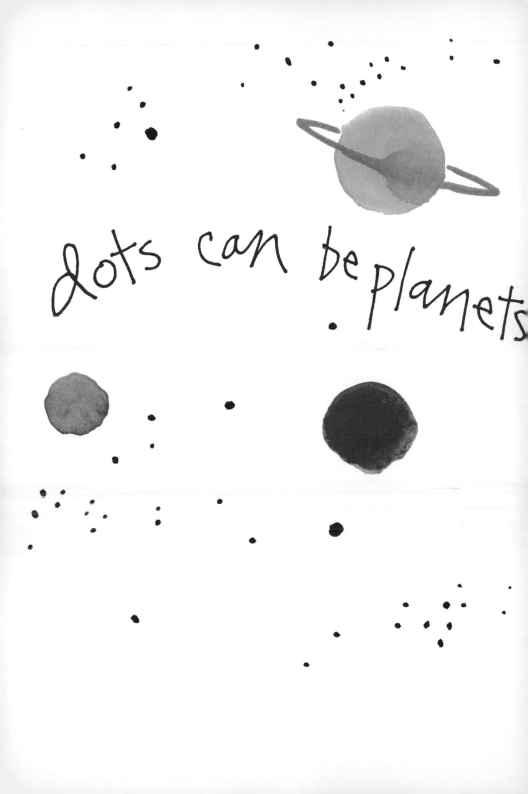

dots can be planets

and stars.

Use this space to create your

own imaginary dot universe.

Dots can become clocks.

What time
did you wake
up today?

Your favorite
time of day?

What time were you born?

What time is it right now?

Mindful Marks
.

Forget about
clock-time.

Put on some music.

Let the beat
inspire you.

Let your dots dance across the page...

Now take a dot for a walk.
Draw a line. Start here.

(End whereever you want!)

Be sure to sign your name.

Fill this page with lines

— short, long, continuous.

IT'S UP TO YOU! LET IT FLOW...

Take a look back
at your lines.

Are they...

- [] Thin?
- [] Thick?
- [] Horizontal?
- [] Vertical?
- [] Squiggly?
- [] Short?
- [] Long?
- [] Wild?

Try a line you haven't tried yet.

Mix it up! HAVE FUN!

Let your line take you places.

Lines on lines
make cross-hatching.
GIVE IT A TRY.

Try drawing lines

with different art supplies.

LINE. LINE. EVERYWHERE A LINE.

Choose your favorite
pen, marker, or pencil,
and FILL these pages.

Try one swirling, meandering
continuous line.

START HERE
↓

↑
END HERE

Mindful Marks

So, how's your day going?
Let your hand make the
line it wants to make.

Your lines here

Draw a line that suits each word.

Quiet

Hysterical

Joyful

Confused

Try new colors & art tools.

Headstrong

Timid

Swirly

Excited

Imagine your line is the path

of a bee flying in the field.

Mindful Marks

· · · · · · · · ·

Take a deep breath...
Exhale and drag your pencil
around and around in a circle.
but keep your eye on the
center.

Free space! Do your own thing!

What would you like to see here?

These pages need your creativity!

Draw waves...

Draw Zig-Zags...

Which matches your state of mind
right now?

You can start
Small.

You can
Keep going.

You can be
a bit braver
each day.

You can
DREAM BIG.

Trace your hand with a continuous line.

Write five things important to you on each finger.

Draw a cup or a mug with one continuous line…

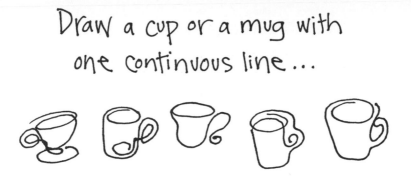

Find another common object
and draw it without picking
up your pen.

Choose another object and keep your eyes on it as you draw— no looking at the page.

(This is called a blind contour drawing.)

Now draw blind. Shut your eyes and draw
the object one more time.

Don't worry about getting it "right" or making it "perfect."

Creativity isn't always pretty.

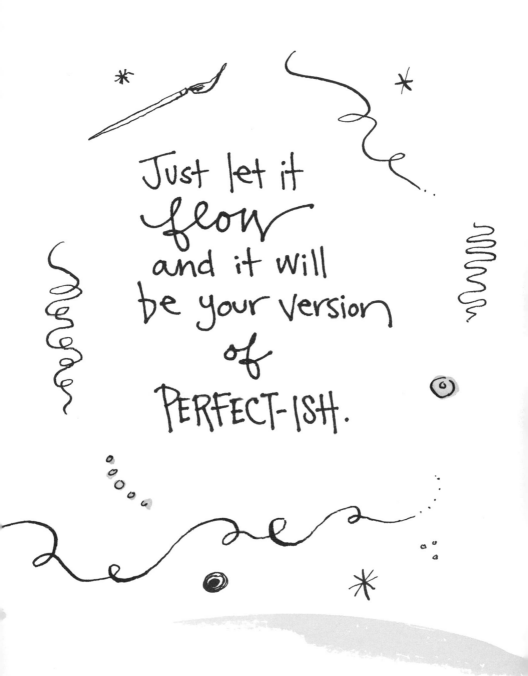

Just let it
flow
and it will
be your version
of
PERFECT-ISH.

Get messy. Cut loose.

So We All Love Lines

But don't you
miss those
dts?

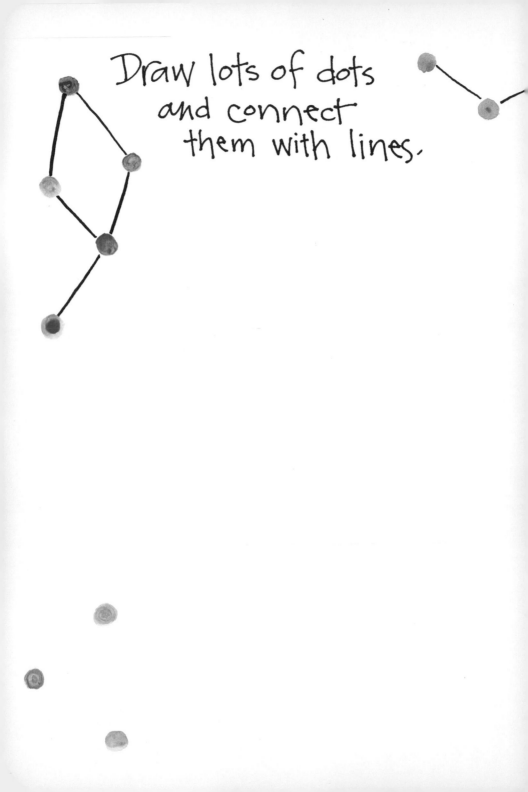

Draw lots of dots
and connect
them with lines.

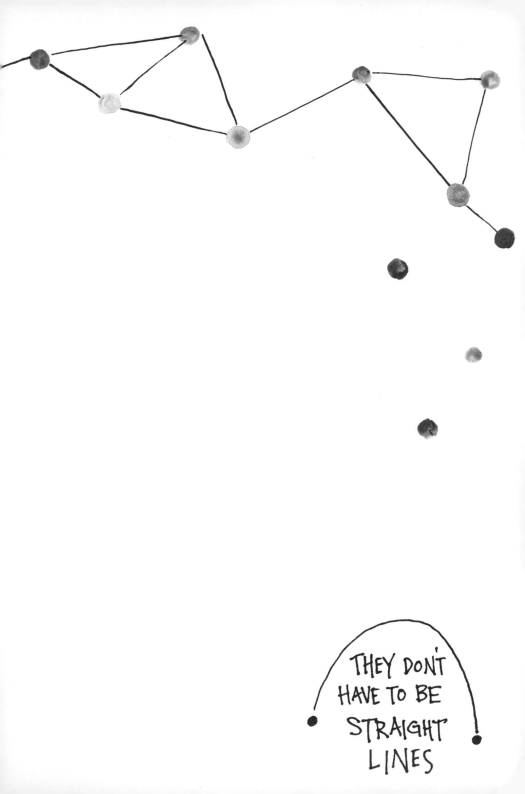

THEY DON'T
HAVE TO BE
STRAIGHT
LINES

Fill these pages
with dots and
lines.

Lines and dots...

DOTS

and LINES.

Dots and lines
make
great things
together.

Choose three colors.

○ = dots
○ = lines
○ = fills

Now... let your dots,
lines, and fills flow!

Try this again
with different colors
and different
size dots.

Fill these pages with your creativity!

Now fill these dots with lines, dashes, stripes, checkerboards, or zigzags!

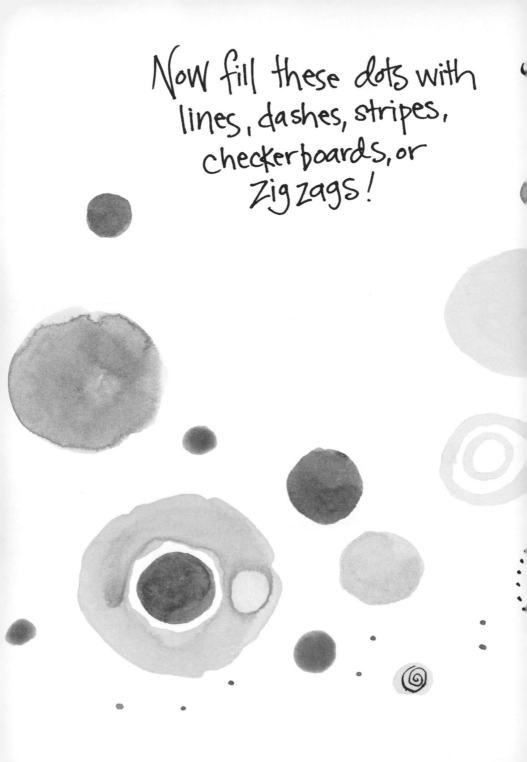

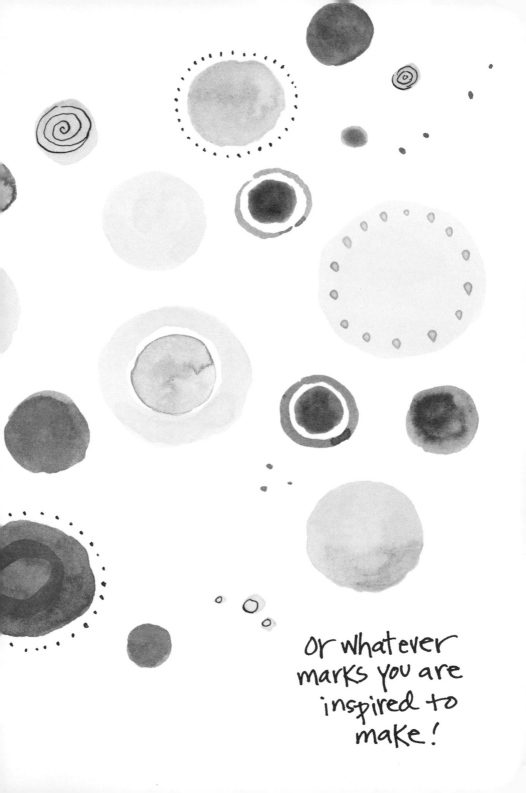

or whatever
marks you are
inspired to
make!

Do it again with different colors and patterns. Dots and lines offer endless possibilities.

A sun is
a dot with lines
for rays.

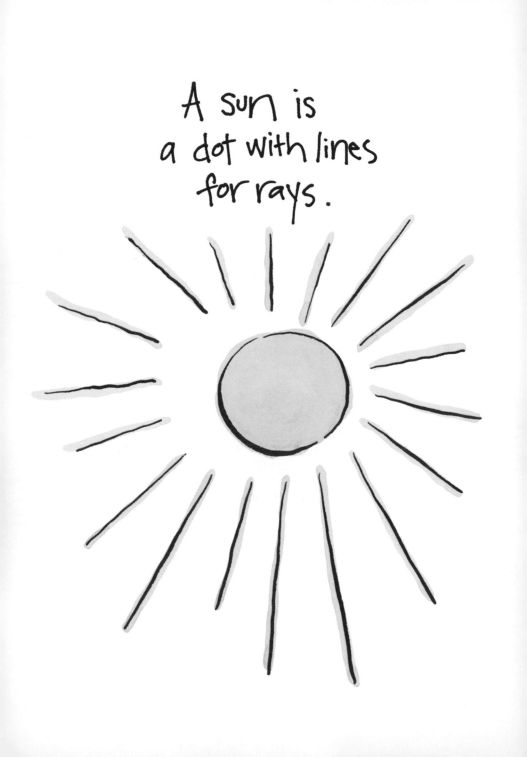

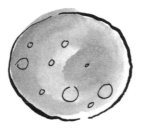

A moon is
a dot filled
differently
each
day.

When it rains,
the clouds drop dots!

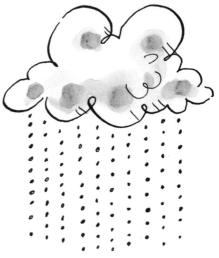

Fill these pages with your own

When it pours —
the clouds drop lines!

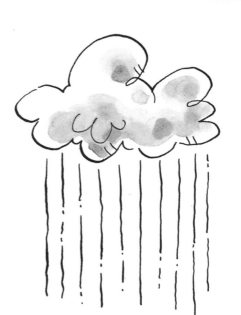

clouds, dot drops, pouring lines.

Look around you.

What else can you
draw with dots
and
lines?

Close your eyes and fill
these pages with dots.

.

Try connecting them to spell your name.

Play with your name.
Draw it. Try it in block letters.

Imbue your name with different

BOMBASTIC

DRAMATIC

Romantic

MANIC

personalities each time you write it.

Bubbly

Flowery

JAGGED

STRONG

Fill these pages with your dots, lines, and, your name

GO NUTS!. GO WILD! Let it flow!!!

Imagine that your dreams, your goals, your hopes were DOTS.

MAKE A DOT FOR EACH AND
LABEL THEM.

For YOUR BIG dreams-make BIG DOTS!

Now...

Ask someone else to
draw a dot in this
frame and...

SIGN IT!

Add one last
D⬤T.
(for now)

↓

(and sign it!)

The End-ish!